friends
18 sept 1999

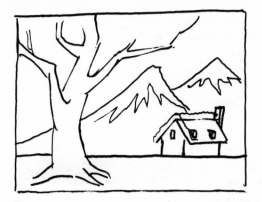

HOW TO DRAW AND COMPOSE PICTURES

Arthur Zaidenberg

ABELARD-SCHUMAN A S LONDON NEW YORK TORONTO

BOOKS BY ARTHUR ZAIDENBERG

How to Draw Athletes in Action
How to Draw Ballet and Other Dancers
How to Draw Birds, Fish and Reptiles
How to Draw Butterflies, Bees and Beetles
How to Draw a Circus
How to Draw and Compose Pictures
How to Draw Costumes and Clothes
How to Draw Dogs, Cats and Horses
How to Draw Farm Animals
How to Draw Flowers, Fruit and Vegetables
How to Draw Heads and Faces
How to Draw Historic and Modern Bridges
How to Draw Houses
How to Draw Landscapes, Seascapes and Cityscapes
How to Draw Military and Civilian Uniforms
How to Draw Motors, Machines and Tools
How to Draw Musicians and Musical Instruments
How to Draw People at Work
How to Draw Period Costumes
How to Draw Prehistoric and Mythical Animals
How to Draw Shakespeare's People
How to Draw Ships and Trains, Cars and Airplanes
How to Draw Wild Animals

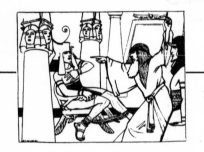

© Copyright 1971, text and illustrations by Arthur Zaidenberg
Library of Congress Catalogue Card Number: 78-141862
ISBN: 0.200.71762.6 (Trade)
 0.200.71772.3 (GB)

LONDON	NEW YORK	TORONTO
Abelard-Schuman	*Abelard-Schuman*	*Abelard-Schuman*
Limited	*Limited*	*Canada Limited*
8 King St.	*257 Park Ave. S.*	*228 Yorkland Blvd.*
WC2	*10010*	*425*

AN Intext PUBLISHER

Printed in the United States of America
Published on the same day in Canada by Abelard-Schuman Canada Limited
Designed by The Etheredges

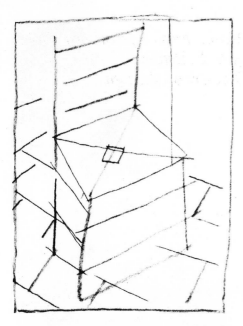

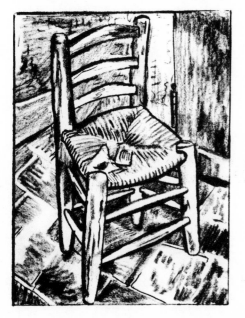

CONTENTS

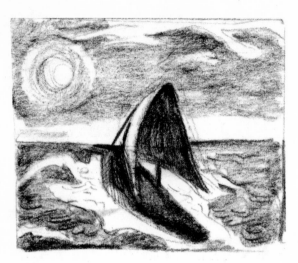

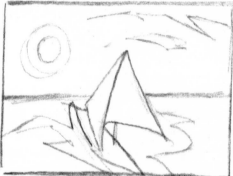

Drawn from a painting
by A. P. Ryder
"Toilers of the Sea"

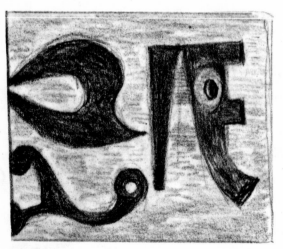

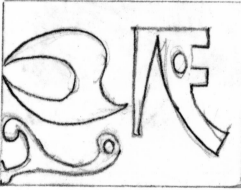

Drawn from a painting
by Baziotes
"Dragon"

INTRODUCTION

A picture is a very special thing. Every drawing, even some of the works of the great masters, cannot be called pictures. Being framed and hung on a museum wall does not give a piece cf artwork—no matter how beautiful it is—the privilege of being called a "picture."

What, then, is a picture and what is so special about it?

Let's make a few comparisons.

In studying grammar at school, you learned that a phrase is not a sentence unless it contains certain parts of speech (subject, verb, predicate).

In science, you learned that a theory does not become an axiom— an established principle or law of science—until it has been proven to the satisfaction of competent scientists.

A good picture is comparable to a complete sentence or a proven theory when it is a source of satisfaction to the artist himself and to competent viewers. The artist starts out to "say something" in the limited area of his paper or canvas and succeeds in saying it completely and convincingly.

Unlike a sketch, a picture is a complete statement and leaves no unconsidered areas of space, no haphazard relationships of forms and tone, and no movement of action unsuited to the boundaries of his work area. A poor picture violates all these considerations and is like an incomplete sentence or an unproven theory.

In the following pages, we shall deal with the principles of composition, design, balance, movement and tonal values—which are the components of a good picture.

MATERIALS

There are a great many varieties of drawing materials and, throughout your art studies, it will be fun to try as many as possible until you find those best suited to your needs.

In this book, I have used carbon drawing pencils or India ink with a pen or fine sable brush. These are, of course, available in most stationery stores and in art-supply shops, along with drawing paper suitable for use with them.

The term "drawing" does not mean that you will be restricted to black and white and the shades of gray in between. Pastels and colored chalk and crayon are also drawing materials.

However, in order to avoid complicating your study of basic picture drawing and composition, it is advisable to work with materials similar to those used here, making departures into the use of more colorful materials as your skills and knowledge advance.

THE BASIC DRAWING MATERIALS YOU SHOULD HAVE

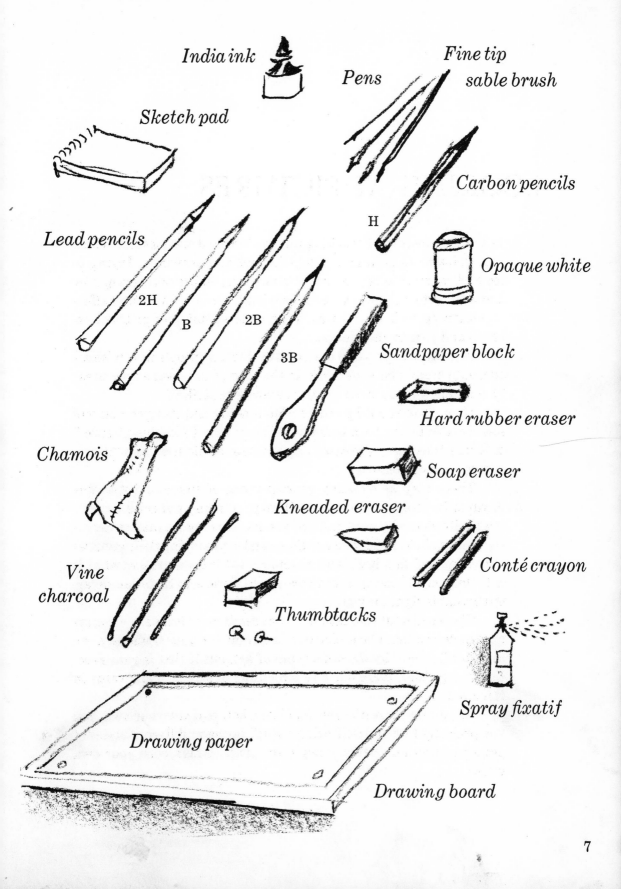

India ink

Pens

Fine tip sable brush

Sketch pad

Carbon pencils

H

Lead pencils

Opaque white

2H

B

2B

3B

Sandpaper block

Hard rubber eraser

Chamois

Soap eraser

Kneaded eraser

Vine charcoal

Conté crayon

Thumbtacks

Spray fixatif

Drawing paper

Drawing board

LOOKING AT PICTURES

There is no method of teaching anyone how to draw pictures which is as valuable as looking at fine paintings and drawings. Trying to see each work through the artist's own eyes in order to grasp how and why it affects *you*—rather than what it contains—is a most effective learning tool. In this way, your understanding of pictures expands and your taste develops.

A common expression is attributed to many people who, without adequate study and experience in the field of art, look at pictures: "I don't know much about art but I know what I like."

If you look at good pictures with interest and thought, you will soon be able to say with honesty, "I know *why* I like this picture." You will then have a greater appreciation of pictures as well as a source of much pleasure.

There may be so many reproductions of fine and not-so-fine pictures in books at your local library, so many galleries in your town with shows by good and bad artists, so many magazines carrying stories about fashionable artists—and reproducing their pictures—that you will find it difficult to know what is good art and what is not. Only experience and your own good sense and taste can determine what is right for you.

The wonderful expression, "That sends me!" is a very effective way to determine which pictures are right for you. Obviously, we are not all "sent" by the same types of art, but if that is your reaction to a picture, there must be something of strength and value in it for you.

As you see more pictures and learn how to draw your own, you will probably find yourself being "sent" by many different styles of art expression and perhaps begin to "send" others with your own work!

THE MAKING OF PICTURES

Making a picture requires two important processes.

The first is receiving an impression and absorbing it by seeing with the visual and mental eye.

The second is telling others about what you have seen and thought by creating a visual expression of it on paper or canvas, for their understanding and pleasure.

The subject of your picture need not be grand or important. It can be as simple and unpretentious as an old chair. Van Gogh, a great and passionate artist, poured all his emotion into that humble subject.

The degree of beauty or excitement brought to the viewer does not depend on the subject of the picture but on the substance of what the artist has seen, and how he has communicated it.

First, begin to *see*. Try to look at commonplace things with a fresh eye as though you are seeing them for the first time. Qualities that never struck you before will be revealed and you will begin to see as an artist does. When this starts to happen, you will have taken the first step toward the making of pictures.

The use of the various tools and drawing and painting materials available to artists, and the composition of well-built pictures can be learned. With practice, you can become skillful at drawing and composition.

Add to these abilities your own fresh vision, excitement and honest emotion and you will create good pictures and possibly even great ones.

COPYING

The word "copy" has acquired a nasty connotation in our times due to the confusion between what, in the past, had been a popular activity for young artists, and the "forging" of pictures by dishonest artists in order to sell the fakes as originals.

Instead of using the word *copy*, let's call the method of study suggested in the following pages *paraphrasing*. This simply means saying the same thing in different words or rewording a thought that was expressed before.

The great French artist, Cezanne, paraphrased an ancient painting by Del Piombo, "Christ in Limbo," using the same figures and composition but his own style of painting.

Van Gogh paraphrased Delacroix's "Pieta," also putting his own personal qualities into the copy.

Manet, another fine French artist, made a paraphrase of Goya's "The Shootings of May 3, 1908" and called it "The Execution of Maximilian."

Soutine painted "The Flayed Ox," a work which resembles, and was very much influenced by, Rembrandt's painting of the same title.

Many other examples of the use of themes and compositions from fine pictures for retelling by other artists, in their own special manner, hang in museums and are honored, as long as their original source of inspiration is acknowledged.

For study, examples of a few drawings made from famous paintings are shown on the following pages. They are not intended as copies, nor would it be possible to copy them since drawings of paintings obviously cannot have the same character as the paintings themselves. The purpose of such paraphrasing in a different medium —in this case, making pencil drawings from paintings—is to draw inspiration and instruction from the concepts of fine artists and to express them in one's own art language.

INFLUENCE

To be influenced by someone else's work does not mean that you have given up your own unique approach to drawing or painting. No fine artist ever arrived at his full stature without being influenced by others.

In Japanese art, when an artist has mastered a technique of drawing—let us say, a bird's wing or a mulberry leaf—other artists adopt this technique without giving up their own. The wonderful heritage of art available to all of us should be added to our own special knowledge and experience.

Many examples of such valuable use of influence can be found among the great masters of Europe as well as those of the Far East.

Raphael, for example, took much from others but in each picture he painted, he added something of himself, with the result that he produced greater works than those from which he borrowed.

Do not hesitate to be influenced by the work of other artists whom you admire, but do not lose your own "handwriting" in the process.

PERSPECTIVE, PROPORTIONS, VALUES

Many artists draw pictures as though the borders of their paper or canvas are like the frame of a window through which they are depicting a scene. The scene contains various objects—some close and others that are receding far into the distance.

Since the artist must draw that scene on a flat surface, it is necessary for him to resort to eye-fooling tricks in order to create the impression of distance.

There are three eye-fooling tricks that can be used to convey the impression of distance:

1. *Perspective*—You have probably noticed how a road or railroad tracks seem to grow narrower as they recede in the distance, until they appear to meet at the horizon. The point at which they meet is called the vanishing point.

 The drawing which follows (PLATE A) will show some forms in simple perspective, above and below the horizon line, and you will see how an impression of distance is suggested.

2. *Proportion*—This is another drawing trick to fool the eye. An object close to your eye appears to be larger than one that is further away although the latter, in reality, may be considerably larger than the one you are seeing close up.

 PLATE B is an example of a great mountain peak that is dwarfed by the figure of a man. Below, the mountain begins to assume its proper proportions in relation to the man.

3. *Values*—The darkest dark and the lightest light are closest to your eye and this truth, along with the gradations of gray to white, helps tell the story of depth and distance in a picture (see PLATE C). Long shadows cast by small figures suggest that the position of the figures is deep within the picture space.

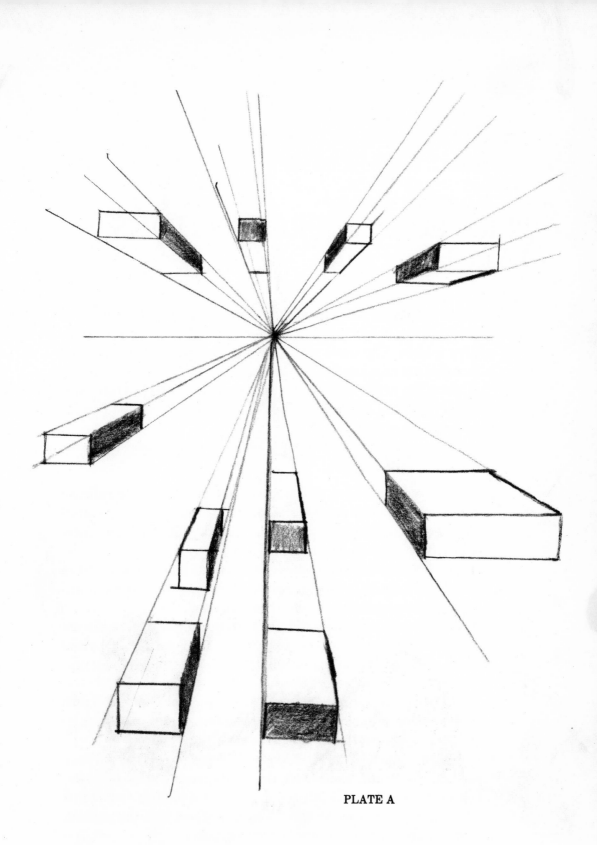

PLATE A

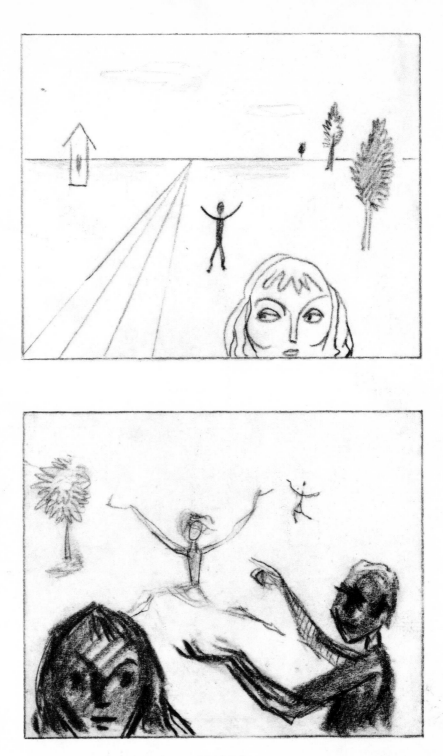

PLATE B

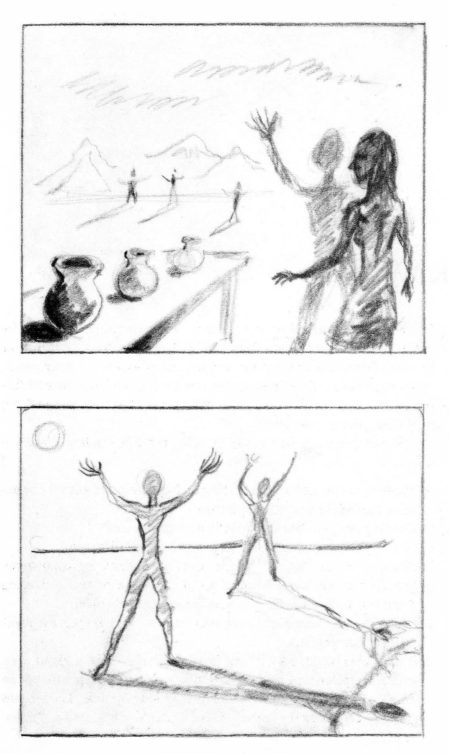

PLATE C

DRAWING

In this book, we are *drawing* pictures, not painting them, and the variations in "color" in the drawings will be indicated by differences in tone. Tones are created by varying the pressure on your pencil when you are drawing lines, and by shadowing, which is done by filling in areas of the drawing with solid tones that may range from very light gray to deep black.

Several purposes are served by using tones of shading. Here are a few:

A. Shading is one method of creating an impression of a third dimension, that of thickness, in a picture.
B. Shading suggests air and light in a picture space.
C. Shading helps to create the illusion of depth or distance.
D. Shading is the "paint" which gives your drawing color, even though the colors are gradations of the value of tones ranging from white, through all the variations of gray, to black.
1. As mentioned before, shading may be done by varying the pressure on your pencil.
2. It may also be done by filling in the boundaries of a given area with a complete tone of gray or black, using either the side of the pencil point or many even lines placed side by side. Even tones may be produced by many closely placed dots or by "crosshatching."

Here are examples of these shading methods and what they can suggest in your picture.

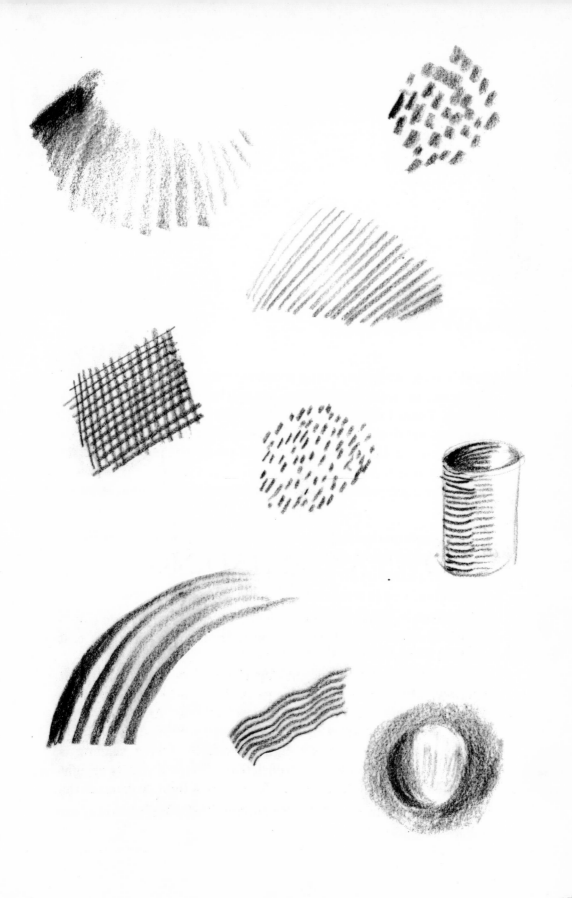

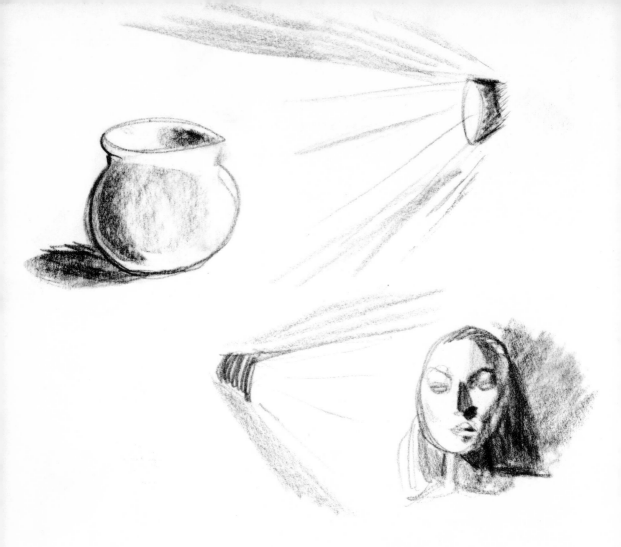

SHADOWS AND SHADING

All objects are subjected to light when we can see them and consequently they have shadows cast upon them which, in turn, cast shadows.

No object is so transparent that 100% of the light cast upon it can penetrate it. Some small changes in the value or intensity of the light occur even when it passes through clean glass. And a glass window or a tumbler obstructing light will throw a faint shadow.

Opaque objects obstruct light completely and a shadow is thrown of an intensity which is consistent with the intensity of light thrown on the obstructing object. The source of light determines the direction of the shadow that is thrown behind the object.

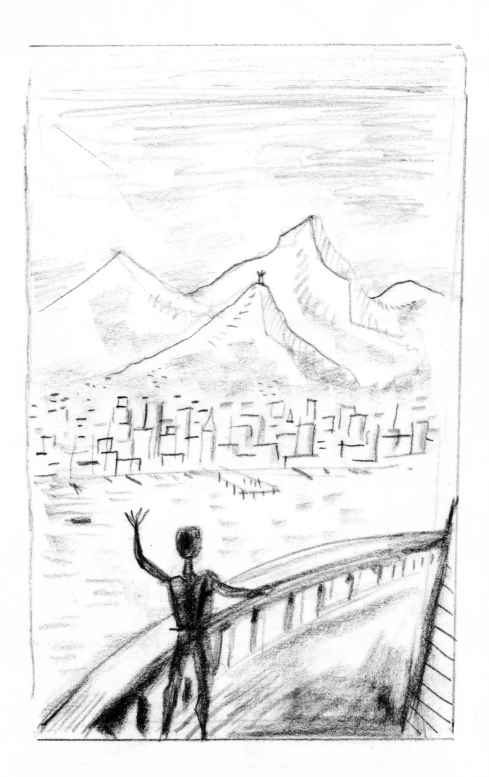

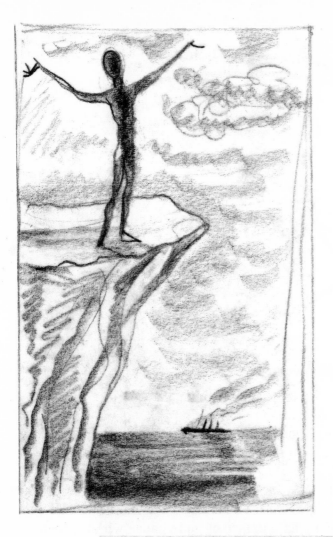

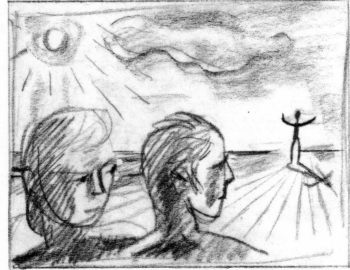

LINES

A line drawn with a pencil can be a *living* thing.

It can express emotion. It can be delicate or strong. It can dance or be rigid. It can be full of action or limp and reposed. It can "say" many things to you.

In nature, there is no such object as a line. All solid matter has three dimensions: height, width and depth.

Draw lines on the flat surface of your paper with a pencil so that they not only suggest the emotions and actions mentioned above but also enclose areas of white paper with boundary lines to "suggest" solid forms of nature.

These boundaries can be simple fences of pencil lines like those made by a little child or they can be beautiful and varied.

The thickened lines in the facing plate imply something quite different from "pure line." These are the beginning of tonal areas or "values," the name given to varying depths of light and shade. Although these areas are made up of lines, their intent is to convey the impression of a solidly filled tonal area. Such thickened lines, drawn with the long edge of the carbon pencil, will be important to you later when you practice drawing shaded and toned three-dimensional figures. They are shown here for the purpose of contrast with "pure line."

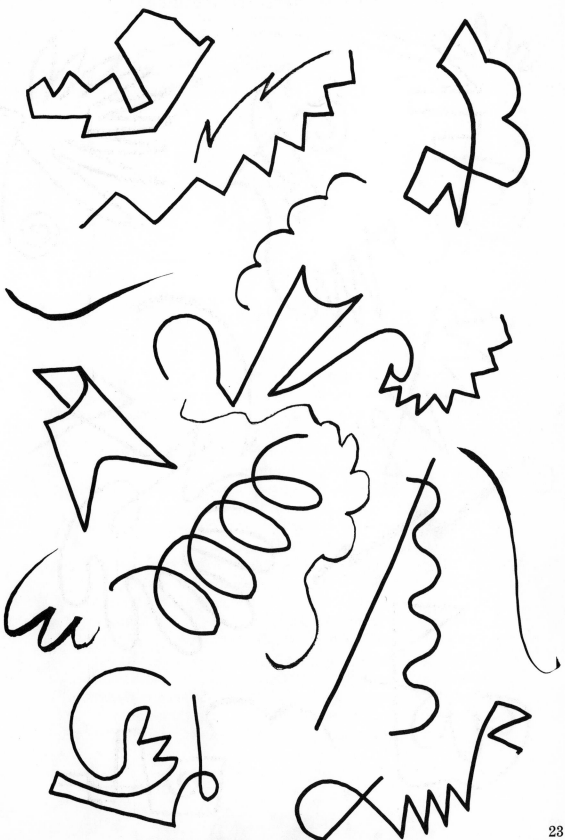

Practice playing with design in line
and
combine them in compositions

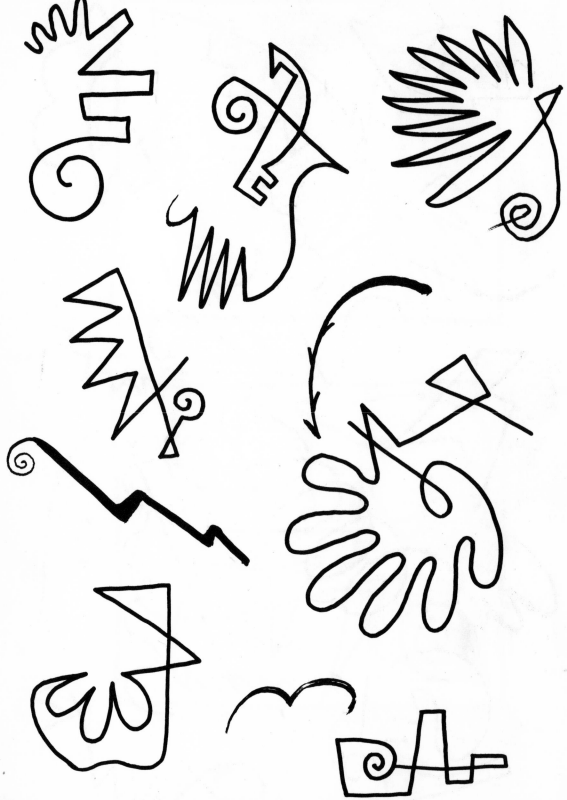

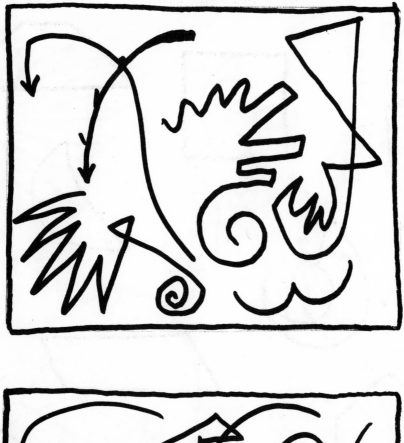

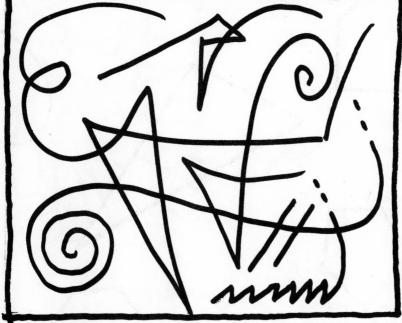

Practice drawing flat shapes
and make compositions
by combining them

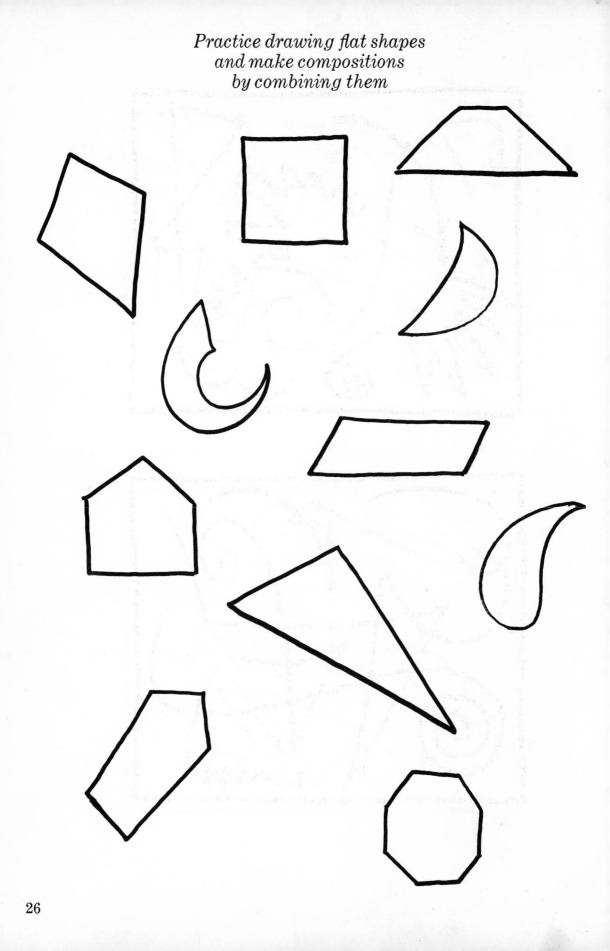

26

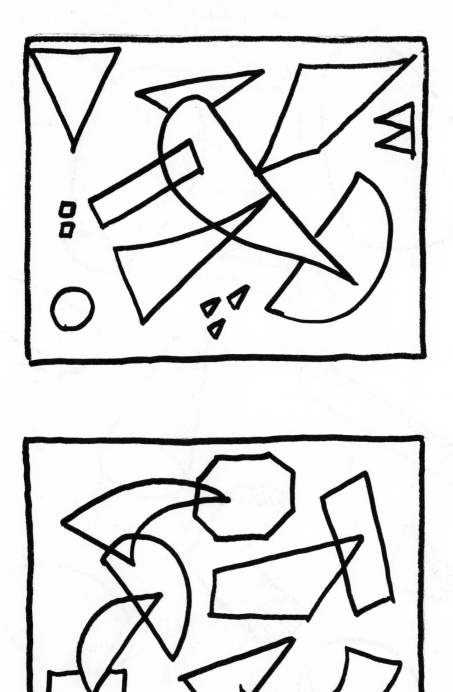

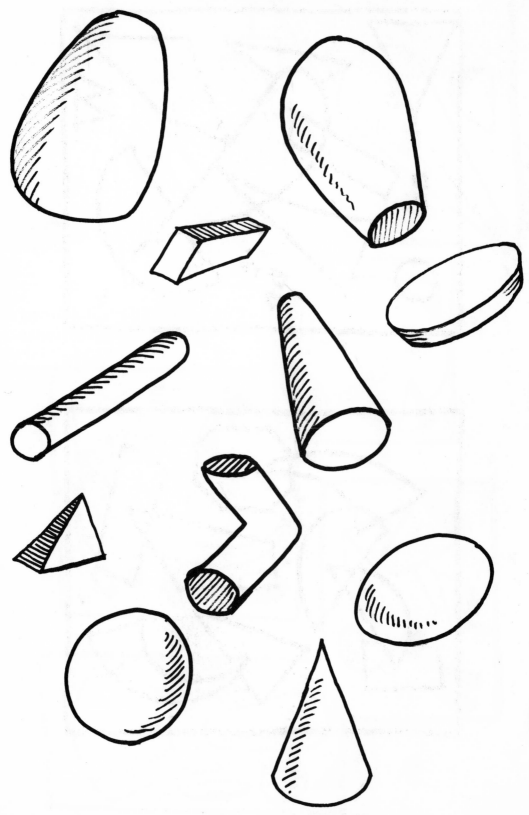

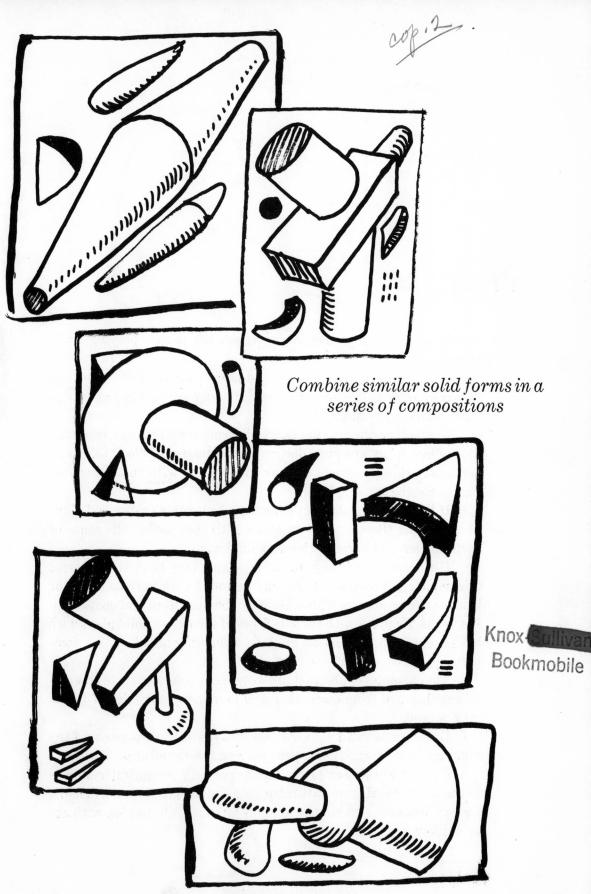

cop.2.

*Combine similar solid forms in a
series of compositions*

29

PLAY

A delightful aspect of a modern artist's life is the "playing while working."

Many modern artists draw and paint pictures which they call "abstractions" or "nonobjective art." These words are not as hard to understand as you might think.

Abstract forms are shapes which do not represent any recognizable object. They are pure designs, not intended to "look like" any particular thing, natural or man-made. It is with these invented forms that the artist "plays."

If he is making abstract drawings, he invents shapes and plays at arranging them in a given space until they satisfy his sense of taste, his sense of humor or his sense of drama.

His drawings of these forms or shapes may be circles, squares or completely irregular. They may be toned with various grays or blacks or they may be white. He may combine lines and spots with his forms. He plays with various types of forms as a child plays with blocks, but with the serious purpose of making a "whole,"—a complete—picture.

The examples of abstract drawings shown demonstrate how different they are from each other and how many varieties of forms may be used.

Draw some small squares and oblongs on your paper and try "playing" with forms, using *your* personal taste and sense of play.

Even if you prefer to draw pictures with recognizable objects in them, borrowed from natural or man-made sources, you will learn a great deal about making good compositions while playing with abstract forms.

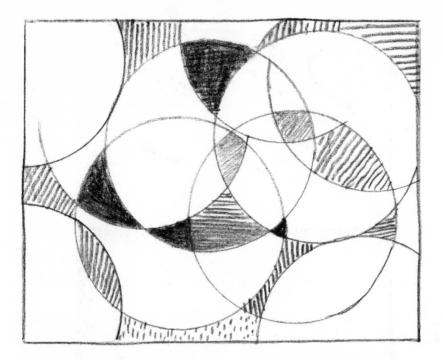

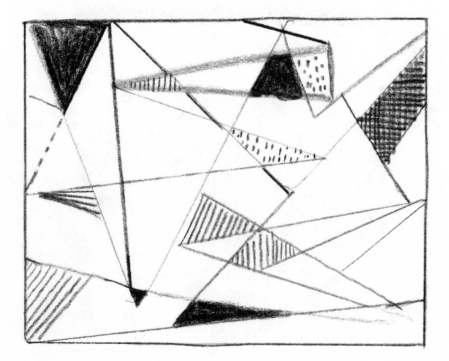

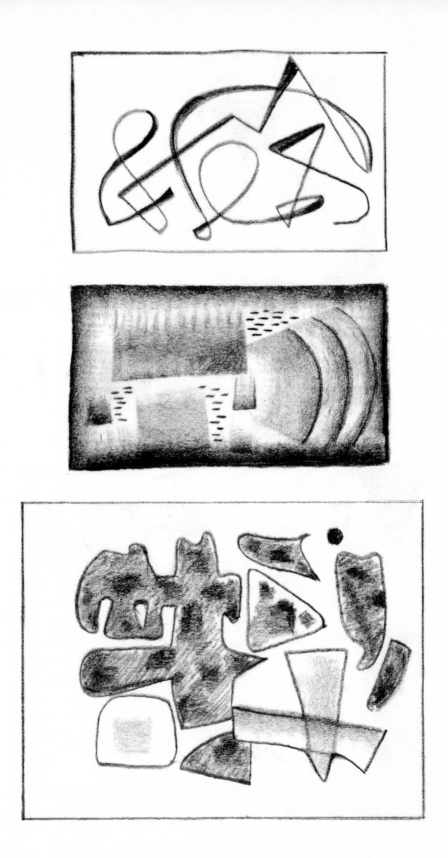

THE STORY

Every picture must have a story to tell even if it is an abstract or nonobjective painting, many of which you have seen reproduced in magazines and hanging in galleries.

Despite the absence of recognizable objects or people in such pictures, they are still intended to communicate a story to the beholder —an emotional statement by the artist.

In telling his story, the artist tries to utilize all the resources available to him that will help convey that story most forcibly.

Nothing tends to weaken his picture as much as lines, forms and tones which have no part in the telling of the story.

It follows, then, that simplicity and directness are important and all *fine* pictures have those qualities.

An artist sitting at his drawing board with a blank sheet of paper before him may appear to be staring at nothing. If he has already decided on the theme of his picture, what he is doing is deciding on the placement of the forms within the space. If he plans to work entirely from his imagination, he may (as Grandma Moses always did) close his eyes and "see" the whole picture-to-be in his mind's eye.

His own sense of order will automatically place the main forms in the most suitable position in his mental stage set. The forms of lesser interest will be shunted to secondary positions and all paths will lead to the main point of interest in his picture story.

Here are a series of small, thumbnail sketches similar to those which artists make as placement plans for their ultimate picture.

Get into the habit of making tiny composition sketches, trying different arrangements of the spaces and forms until you arrive at the one most satisfying to you. This is very important. If you are satisfied, this does not mean that your composition will please everyone else who sees it, but it is a significant step toward expressing *yourself*. Unless an artist expresses his own thoughts and feelings in his own personal manner, he is not an artist.

Remember the rules of study. Observe, study and practice, using the ideas and methods you admire in other people's work. But always be yourself and people will recognize *you* in your work.

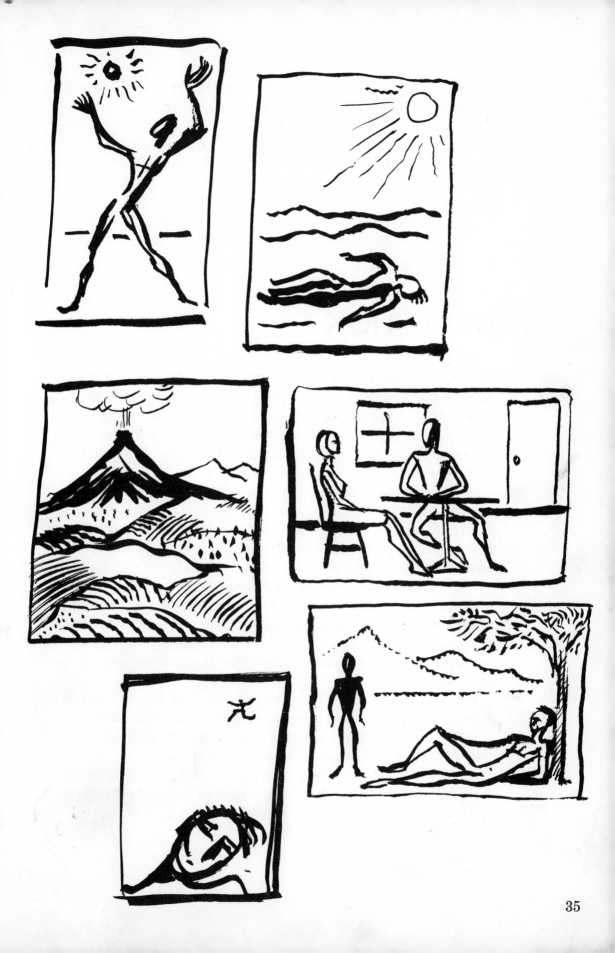

COMPOSITION

Some people have the ability to apply their intuition and knowledge in arranging the contents of a room with taste and a sense of design which will radiate a feeling of warmth and hospitality to a visitor.

The same objects, arranged by someone lacking these qualities, will make the visitor feel he is in a dull and distasteful atmosphere. He has entered a badly "composed" room.

The dictionary defines composition as the act of combining parts or elements to form a whole.

Good composition is easy to "read." There should be no elements in it to detract from what the artist wishes to say. Therefore, it is necessary to be economical in assembling the "parts."

Splendid pictures have been composed containing a vast amount of detail, but in such paintings the arrangement and grouping of the numerous parts required planning so that they "live together" as a harmonious whole.

There are no hard-and-fast rules for good composition, but a few "don'ts" can be pointed out.

Don't unbalance your composition so that you will be forced to fight bad weight-distribution in the course of making a picture.

Don't have too many points of interest in your composition so that the eye is forced to jump all over the place.

Don't "freeze" your composition by a monotonous sameness of the tones in your picture. Let there be light parts and dark parts to add to its interest.

Don't make your composition heavy by a lack of action of the forms in the picture. Characters and objects must look alive and vital.

Try to distribute the important and bulky parts of your picture so that they do not convey the impression of tipping over or bulging the frame or even breaking through the top.

Your forms must live comfortably in the available space, with sufficient "air" around them.

The direction of lines in a composition, the shapes of the full and empty spaces and how those shapes relate to each other make a greater contribution to the quality of a picture than either facial expression—no matter how well done—or fine details in costumes and scenery.

This does not mean that the beauty of nature and the tenderness or drama of human expression are not worthy of your interest and study. But one's attention must not be diverted from the picture as a whole by one special part, no matter how well it is drawn.

The student would do well to study the pictures in this book as well as others, reproduced elsewhere, observing the "wholeness" of the composition, undisturbed by minor parts.

In these pictures, the good artist has concentrated more on knowing what to leave out rather than what to put in.

Human anatomy can be an endless study but frequently a figure drawn with a few thoughtful lines will have more strength and beauty than if detail work that took hours were added. The same applies to leaves or clouds or the details of interior furnishings in a picture.

A composition does not have to stun, deafen, dazzle or explode before your eyes to result in a good picture.

Too many people believe that if a picture has a violent effect and is different enough, it must be better than those that have more serene characteristics. Frequently, a subdued presentation, in carefully controlled tones and forms, has greater impact than one that shouts at the viewer.

In your own drawings, shout if necessary but only if there is an honest reason for it. Otherwise, the noises are meaningless and you will not be heard.

Many people are too shy to draw places and people in public, so they make little sketches and notes at the scene and complete their pictures at home in privacy.

Monotonous balance

Dull composition

Equal division—no play

Better spacing

More interesting

Better design

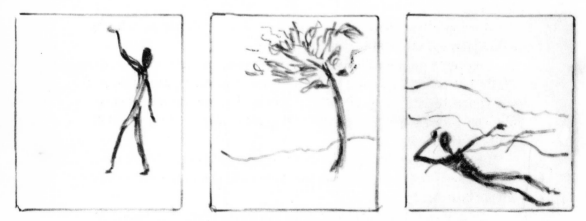

Good spacing and action make good composition

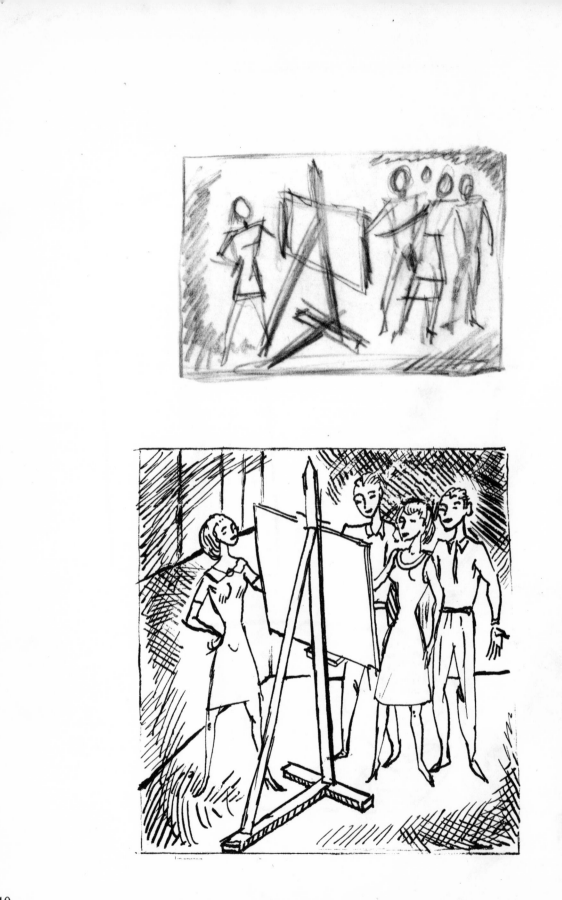

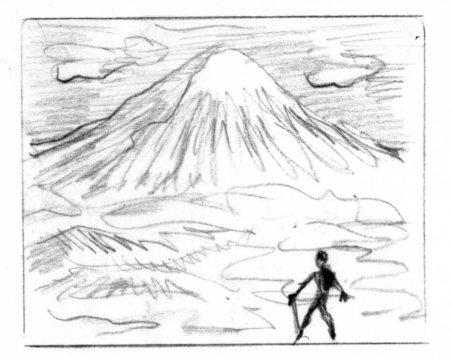

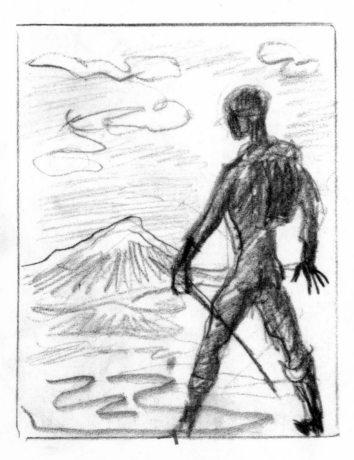

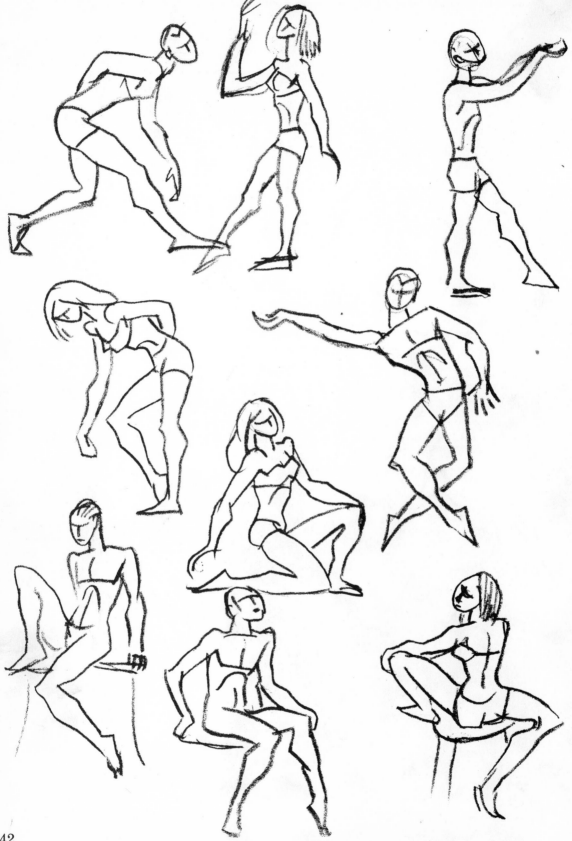

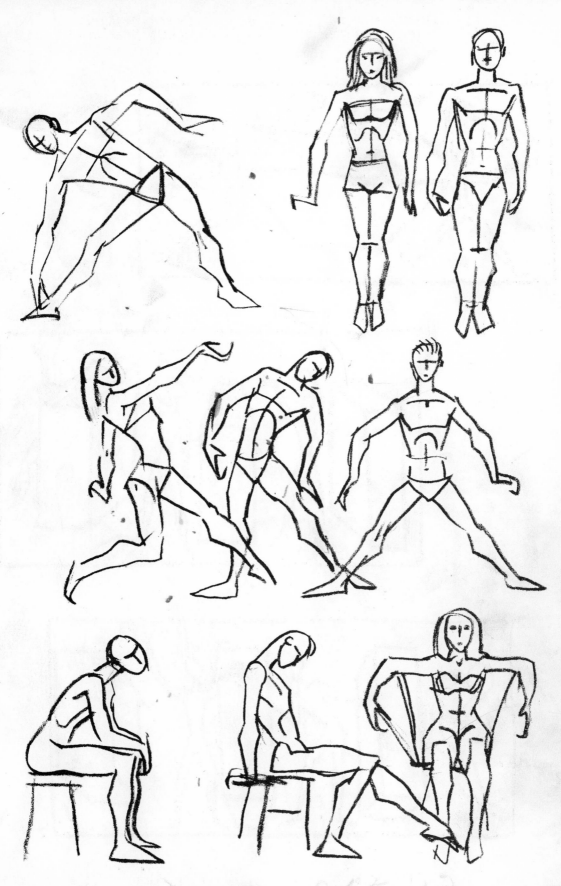

43

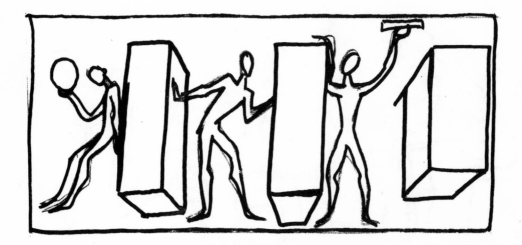

Classic composition movement

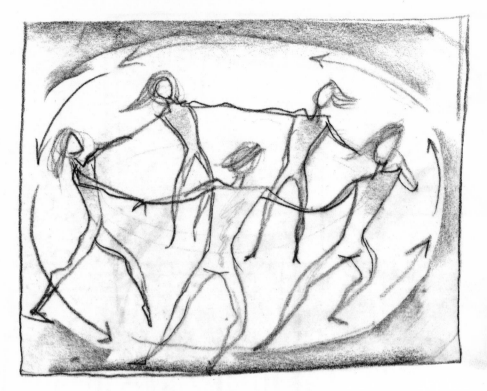

Circular movement

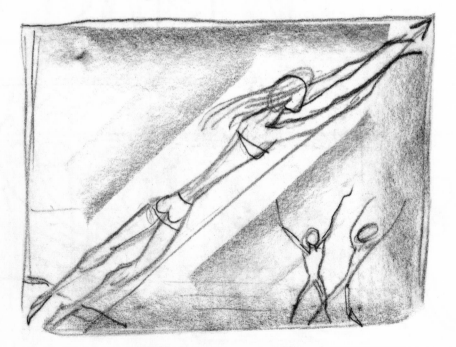

Diagonal movement

Movement can express mood in a composition

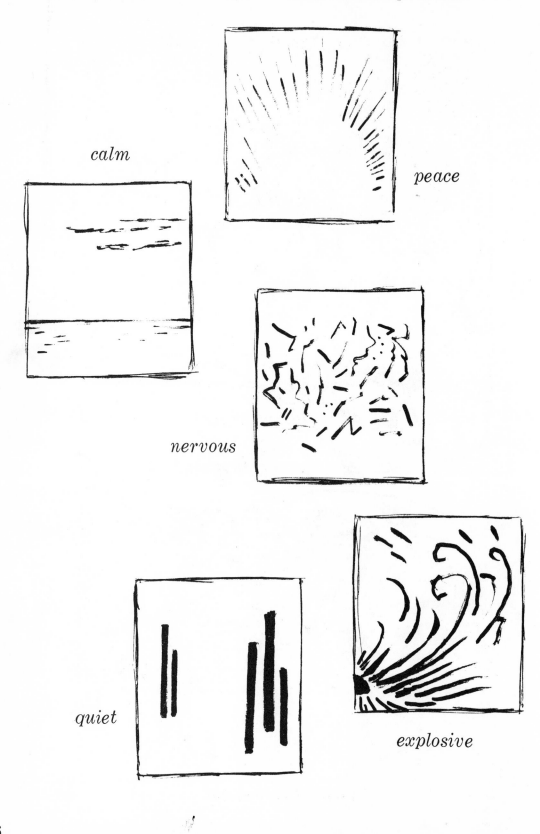

calm

peace

nervous

quiet

explosive

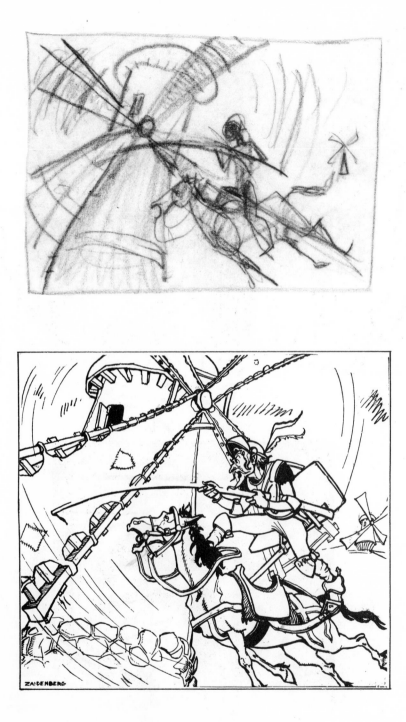

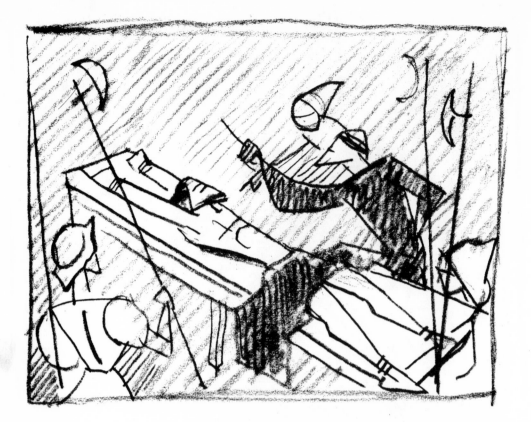

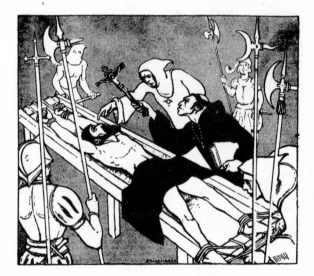

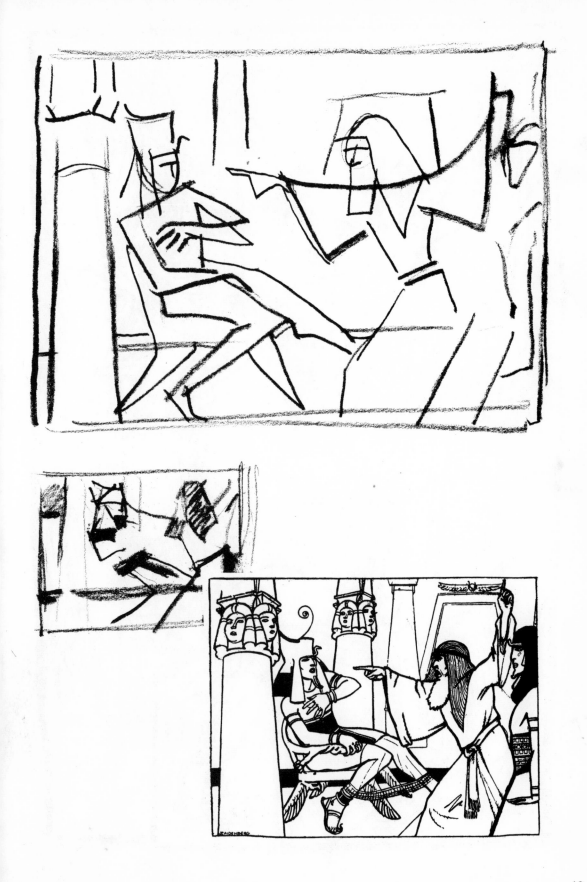

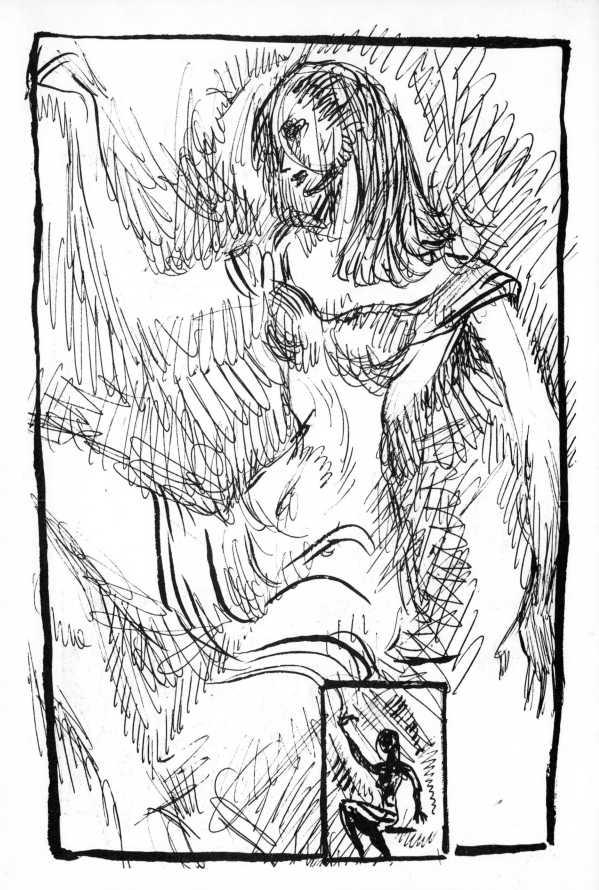

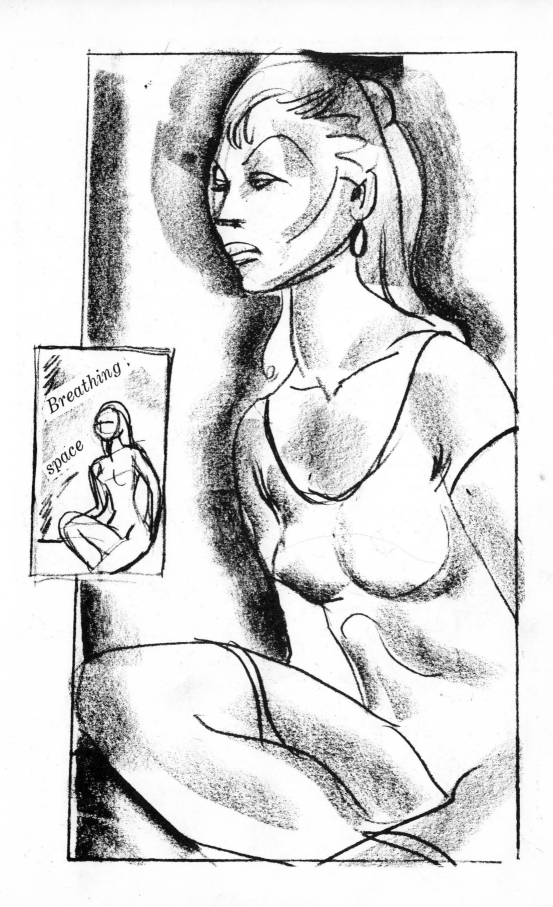

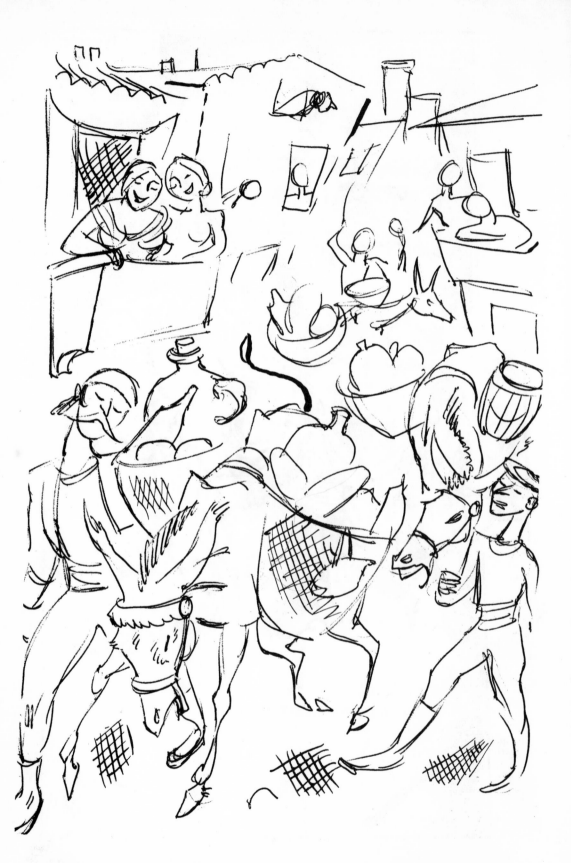

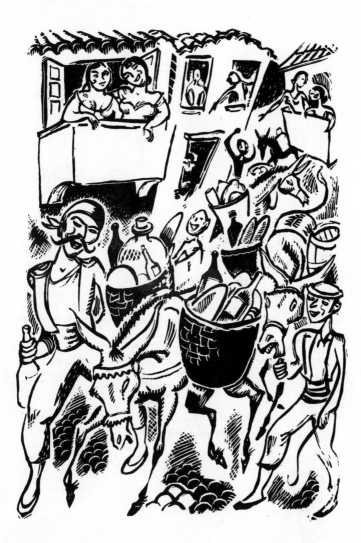

Heavy blacks used to separate forms
in a crowded street scene

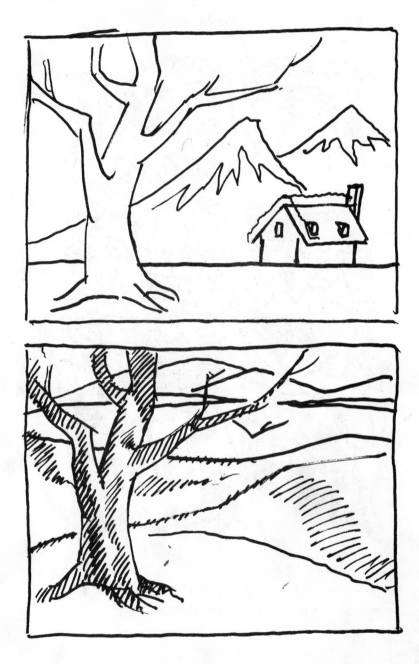

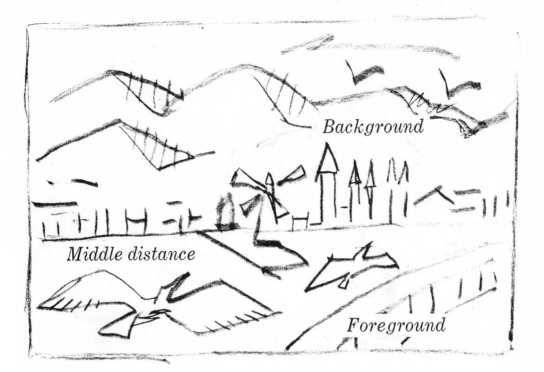

Background

Middle distance

Foreground

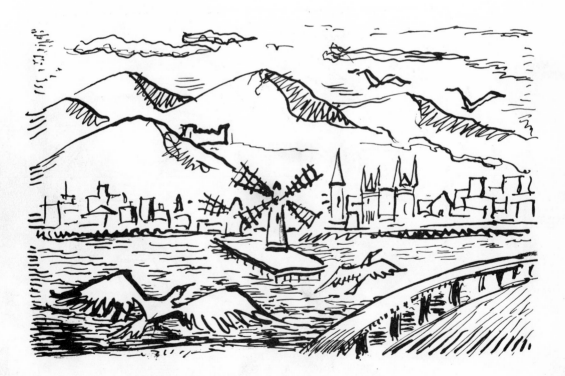

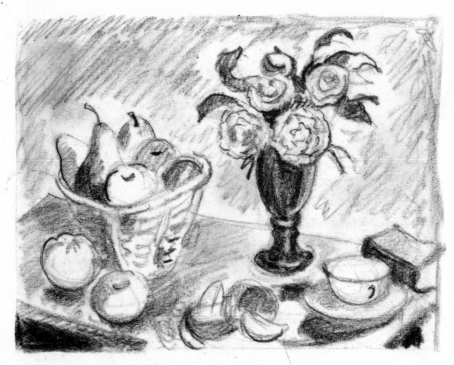

Drawn from a painting by Fantin-Latour "Still-life"

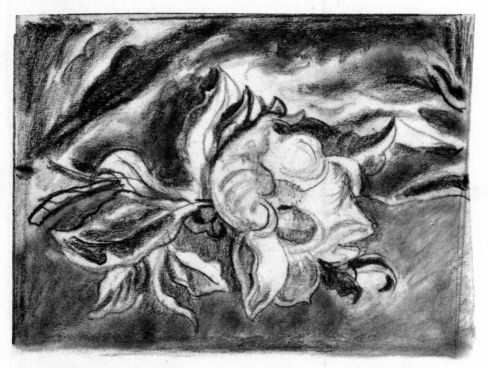

Drawn from a painting by M. J. Heade "Magnolia"

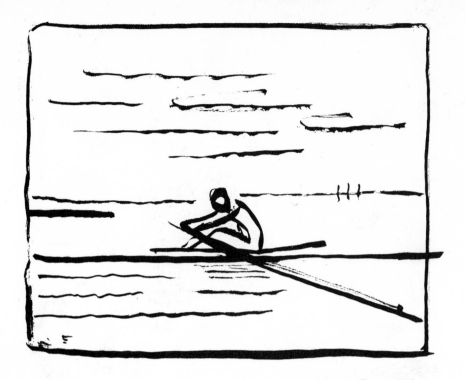

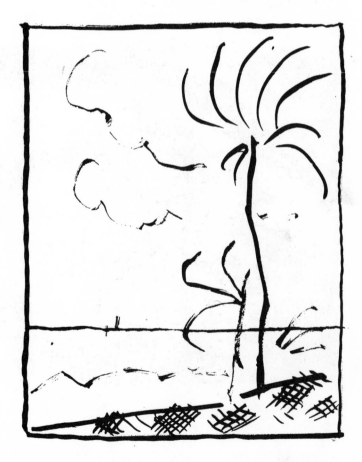

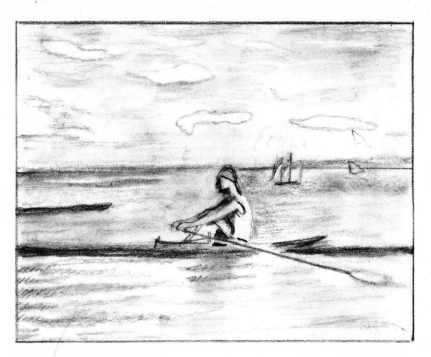

Drawn from a painting by Eakins "Single Scull"

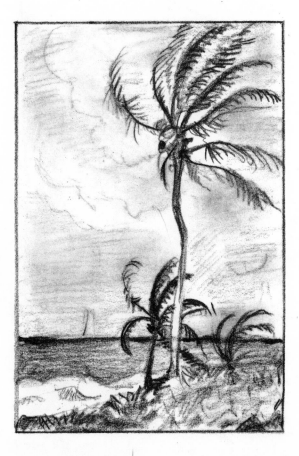

*Drawn from
a painting by Homer
"Palm Tree"*

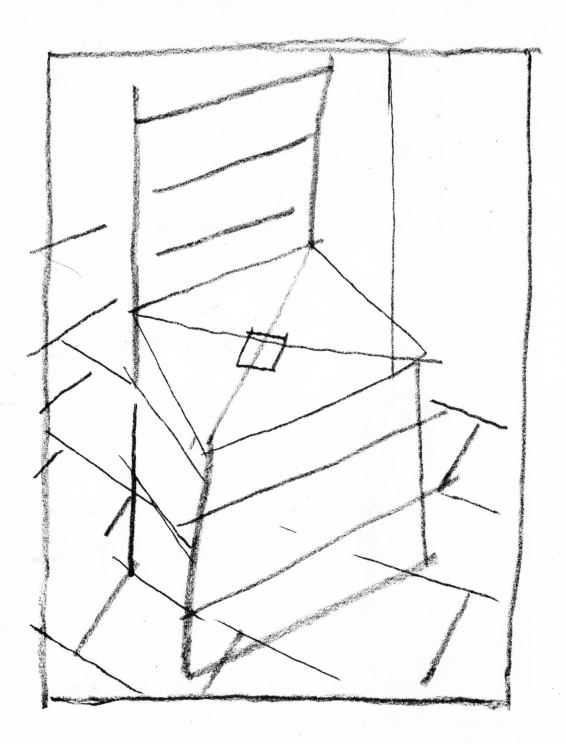

60

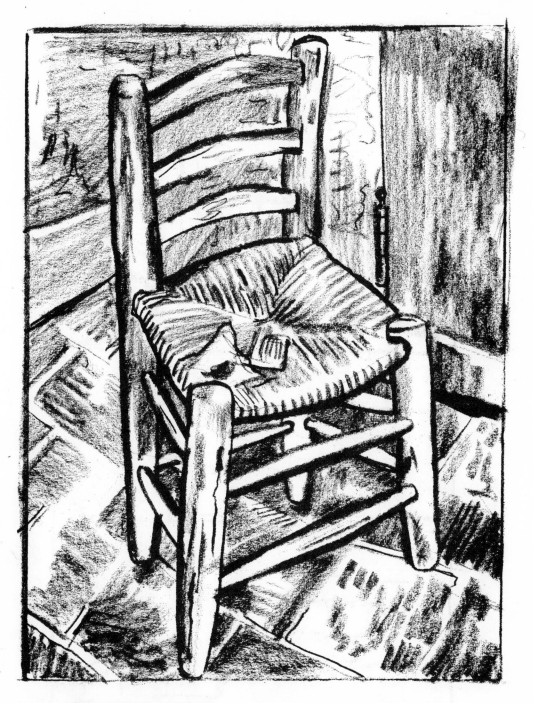

Drawn from a painting by Van Gogh "The Chair"

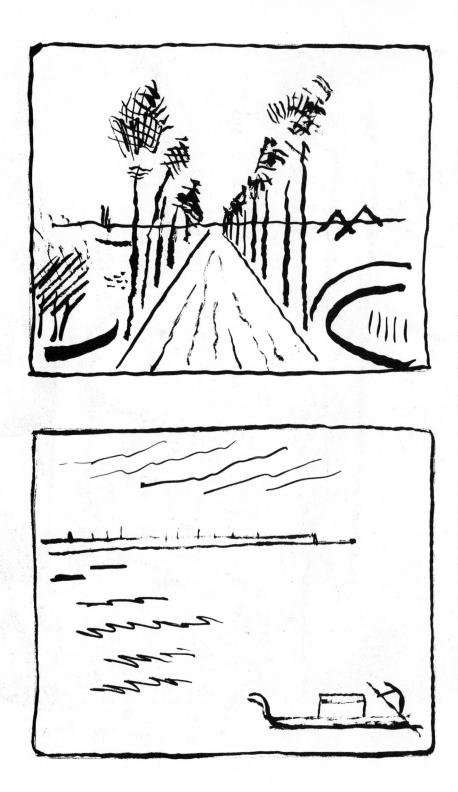

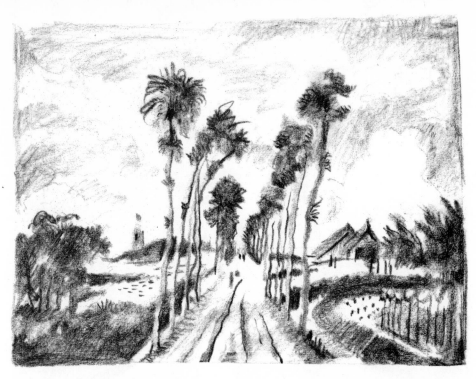

Drawn from a painting by Hobbema "The Avenue"

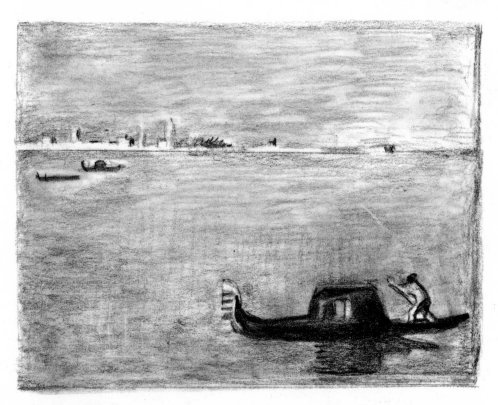

Drawn from a painting by Guardi "Lagoon of Venice"

FINAL WORD

You have now gone through these pages and, I hope, studied them with interest and profit.

However, to acquire the skills of drawing freely and well enough to enable you to say what you wish with your pencil, will require long practice and devotion.

Along with hours of practice, add the time needed to look at art in order to understand the numerous ways in which artists express themselves, while you search for your own, and you will see that a good deal of work lies ahead of you.

But, even though there is a good deal of work involved, there is a great deal of pleasure to be derived from doing that work. And, if you do become an artist and draw fine pictures, you will bring joy to others as well as to yourself.